ISBN 978-1-331-60402-0
PIBN 10211679

Forgotten Books is a registered trademark of FB &c Ltd.
Copyright © 2018 FB &c Ltd.
FB &c Ltd, Dalton House, 60 Windsor Avenue, London, SW19 2RR.
Company number 08720141. Registered in England and Wales.

For support please visit www.forgottenbooks.com

1 MONTH OF
FREE
READING

at

www.ForgottenBooks.com

By purchasing this book you are eligible for one month membership to ForgottenBooks.com, giving you unlimited access to our entire collection of over 1,000,000 titles via our web site and mobile apps.

To claim your free month visit:
www.forgottenbooks.com/free211679

English
Français
Deutsche
Italiano
Español
Português

www.forgottenbooks.com

Mythology Photography **Fiction**
Fishing Christianity **Art** Cooking
Essays Buddhism Freemasonry
Medicine **Biology** Music **Ancient**
Egypt Evolution Carpentry Physics
Dance Geology **Mathematics** Fitness
Shakespeare **Folklore** Yoga Marketing
Confidence Immortality Biographies
Poetry **Psychology** Witchcraft
Electronics Chemistry History **Law**
Accounting **Philosophy** Anthropology
Alchemy Drama Quantum Mechanics
Atheism Sexual Health **Ancient History**
Entrepreneurship Languages Sport
Paleontology Needlework Islam
Metaphysics Investment Archaeology
Parenting Statistics Criminology
Motivational

RED
EARTH

Poems of
New Mexico
by

Mrs. ALICE CORBIN He.

CHICAGO
RALPH FLETCHER SEYMOUR
PUBLISHER

The majority of the poems in this book were first published in POETRY, A MAGAZINE OF VERSE. *From the Stone Age* was printed in THE NEW REPUBLIC; *Trees and Horses* and *Bird-Song and Wire* in THE DIAL; the others appear here for the first time.

CONTENTS

[9]

RED EARTH

RED EARTH

El Rito de Santa Fe

This valley is not ours, nor these mountains,
Nor the names we give them—they belong,
They, and this sweep of sun-washed air,
Desert and hill and crumbling earth,
To those who have lain here long years
And felt the soak of the sun
Through the red sand and crumbling rock,
Till even their bones were part of the sun-steeped
 valley;
How many years we know not, nor what names
They gave to antelope, wolf, or bison,
To prairie dog or coyote,
To this hill where we stand,
Or the moon over your shoulder . . .

Let us build a monument to Time
That knows all, sees all, and contains all,
To whom these bones in the valley are even as we
 are:
Even Time's monument would crumble
Before the face of Time,
And be as these white bones
Washed clean and bare by the sun . . .

LOS CONQUISTADORES

What hills, what hills, my old true love?—Old Song

What hills are these against the sky,
What hills so far and cold?
These are the hills we have come to find,
Seeking the yellow gold.

What hills, what hills so dark and still,
What hills so brown and dry?
These are the hills of this desert land
Where you and I must die.

Oh, far away is gay Seville,
And far are the hills of home,
And far are the plains of old Castile
Beneath the blue sky's dome.

The bells will ring in fair Seville,
And folk go up and down,
And no one know where our bones are laid
In this desert old and brown.

What hills, what hills so dark and cold,
What hills against the sky?
These are the last hills you shall see
Before you turn to die.

THREE MEN ENTERED THE DESERT ALONE

Three men entered the desert alone.
But one of them slept like a sack of stone
As the wagon toiled and plodded along,
And one of them sang a drinking song
He had heard at the bar of The Little Cyclone.

Then he too fell asleep at last,
While the third one felt his soul grow vast
As the circle of sand and alkali.
His soul extended and touched the sky,
His old life dropped as a dream that is past,

As the sand slipped off from the wagon wheel—
The shining sand from the band of steel,
While the far horizon widened and grew
Into something he dimly felt he knew,
And had always known, that had just come true.

His vision rested on ridges of sand,
And a far-off horseman who seemed to stand
On the edge of the world—in an orange glow
Rising to rose and a lavender tone,
With an early start in a turquoise band.

And his spirit sang like a taper slim,
As the slow wheels turned on the desert's rim
Through the wind-swept stretches of sand and sky;
He had entered the desert to hide and fly,
But the spell of the desert had entered him.

Three men entered the desert alone.
One of them slept like a sack of stone,
One of them reached till he touched the sky.
The other one dreamed, while the hours went by,
Of a girl at the bar of The Little Cyclone.

A SONG FROM OLD SPAIN

What song of mine will live?
On whose lips will the words be sung
Long years after I am forgotten—
A name blown between the hills
Where some goat-herd
Remembers my love and passion?

He will sing of your beauty and my love,
Though it may be in another tongue,
To a strange tune,
In a country beyond the seas—
A seed blown by the wind—
He will sing of our love and passion.

IN THE SIERRAS

Do not bring me riches
From your store in the Andes
Do not bring me treasures
From deep ocean caves.
Bring me but yourself
And I'll gladly go with you,
Bring me but yourself,
And I will not be sorry.

Do not bring me patterns
Of silks or of satins,
Do not bring me silver
Or gold wrung from slaves.
Bring me but yourself,
And my heart will rest easy,
And your head will be light
With my breast as its pillow.

Do not bring me servants
Or oxen or cattle,
Or sheep for the shearing
Or ships from the waves.
Bring me but yourself
For my share and my treasure,
Then our fortune will grow
And will never diminish.

IN THE DESERT

I

I have seen you, O king of the dead,
More beautiful than sunlight.

Your kiss is like quicksilver;
But I turned my face aside
Lest you should touch my lips.

In the field with the flowers
You stood darkly.

My knees trembled, and I knew
That no other joy would be like this.

But the warm field, and the sunlight,
And the few years of my girlhood
Came before me, and I cried,
Not yet!
Not yet, O dark lover!

You were patient.
 —I know you will come again.

I have seen you, O king of the dead,
More beautiful than sunlight.

II

Here in the desert, under the cottonwoods
That keep up a monotonous wind-murmur of leaves,

I can hear the water dripping
Through the canals in Venice
From the oar of the gondola
Hugging the old palaces,
Beautiful old houses
Sinking quietly into decay. . . .

O sunlight—how many things you gild
With your eternal gold!
Sunlight—and night—are everlasting.

III

Once every twenty-four hours
Earth has a moment of indecision:
Shall I go on?—
Shall I keep turning?—
Is it worth while?
Everything holds its breath.
The trees huddle anxiously
On the edge of the arroyo,
And then, with a tremendous heave,
Earth shoves the hours on towards dawn.

IV

Four o'clock in the afternoon. . . .
A stream of money is flowing down Fifth Avenue.

They speak of the fascination of New York
Climbing aboard motor-busses to look down on the
 endless play
From the Bay to the Bronx.
But it is forever the same:
There is no *life* there.

Watching a cloud on the desert,
Endlessly watching small insects crawling in and out
 of the shadow of a cactus,
A herd-boy on the horizon driving goats,
Uninterrupted sky and blown sand:
Space—volume—silence—
Nothing but life on the desert,
Intense life.

V

The hill cedars and piñons
Point upward like flames,
Like smoke they are drawn upward
From the face of the mountains.
Over the sunbaked slopes,
Patches of sun-dried adobes straggle;
Willows along the acequias in the valley
Give cool streams of green;
Beyond, on the bare hillsides,
Yellow and red gashes and bleached white paths
Give foothold to the burros,
To the black-shawled Mexican girls
Who go for water.

INDIAN SONGS

LISTENING

The noise of passing feet
On the prairie—
Is it men or gods
Who come out of the silence?

BUFFALO DANCE

Strike ye our land
With curved horns!
Now with cries
Bending our bodies,
Breathe fire upon us;
Now with feet
Trampling the earth,
Let your hoofs
Thunder over us!
Strike ye our land
With curved horns!

WHERE THE FIGHT WAS

In the place where the fight was
Across the river,
In the place where the fight was
Across the river:
A heavy load for a woman
To lift in her blanket,
A heavy load for a woman
To carry on her shoulder.
In the place where the fight was
Across the river,

In the place where the fight was
Across the river:
The women go wailing
To gather the wounded,
The women go wailing
To pick up the dead.

THE WIND

The wind is carrying me round the sky;
The wind is carrying me round the sky.
My body is here in the valley—
The wind is carrying me round the sky.

COURTSHIP

When I go I will give you surely
What you will wear if you go with me;
A blanket of red and a bright girdle,
Two new moccasins and a silver necklace.
When I go I will give you surely
What you will wear if you go with me!

FEAR

The odor of death
In the front of my body,
The odor of death
Before me—

Is there any one
Who would weep for me?
My wife
Would weep for me.

PARTING

Now I go, do not weep, woman—
Woman, do not weep;
Though I go from you to die,
We shall both lie down
At the foot of the hill, and sleep.

Now I go, do not weep, woman—
Woman, do not weep;
Earth is our mother and our tent the sky.
Though I go from you to die,
We shall both lie down
At the foot of the hill, and sleep.

SAND PAINTINGS

The dawn breeze
Loosens the leaves
Of the trees,
The wide sky quivers
With awakened birds.

Two blue runners
Come from the east,
One has a scarf of silver,
One flings pine-boughs
Across the sky.

Noon-day stretched
In gigantic slumber—
Red copper cliffs
Rigid in sunlight.

An old man stoops
For a forgotten faggot,
Forehead of bronze
Between white locks
Bound with a rag of scarlet.

Where one door stands open,
The female moon
Beckons to darkness
And disappears.

CORN-GRINDING SONG

Tesuque Pueblo

This way from the north
Comes the cloud,
Very blue,
And inside the cloud is the blue corn.

> *How beautiful the cloud*
> *Bringing corn of blue color!*

This way from the west
Comes the cloud,
Very yellow,
And inside the cloud is the yellow corn.

> *How beautiful the cloud*
> *Bringing corn of yellow color!*

This way from the south
Comes the cloud,
Very red,
And inside the cloud is the red corn.

> *How beautiful the cloud*
> *Bringing corn of red color!*

This way from the east
Comes the cloud,
Very white,
And inside the cloud is the white corn.

> *How beautiful the cloud*
> *Bringing corn of white color!*

How beautiful the clouds
From the north and the west
From the south and the east
Bringing corn of all colors!

From the Indian

THE GREEN CORN DANCE

San Ildefonso

Far in the east
The gods beat
On thunder drums. . .

With rhythmic thud
The dancers' feet
Answer the beat
Of the thunder drums.

Eagle feather
On raven hair,
With bright tablita's
Turquoise glare.

Tasselled corn
Stands tall and fair
From rain-washed roots
Through lambent air.

Corn springs up
From the seed in the ground,
The cradled corn
By the sun is found.

Eagle feather
And turkey plume
From the wind-swept cloud
Bring rain and gloom.

Hid in the cloud
The wind brings rain
And the water-song
To the dust-parched plain.

[29]

Far in the east
The gods retreat
As the thunder drums
Grow small and sweet.

The dancers' feet
Echo the sound
As the drums grow faint
And the rain comes down.

DESERT DRIFT

Spring

Spring has come
To the apricot boughs;
The cottonwoods
Fringe green on the branches.
Today the flood-gates are opened,
And thin streams loosed
From the high peaks of snow
To acequias in the valley.

Dust-whorl

The wind picks up a handful of dust,
And sets it down—
Faint spiral of lives
Lived long ago on the desert.

Trees and Horses

Trees stand motionless among themselves,
Some are solitary.
Horses wander over wide pastures;
At night they herd closely,
Rumps hunched to the wind.

Bird-song and Wire

The Rocky Mountain blue-bird
Is a point of blue fire;
The meadow-lark
Sings above the hum
Of the telephone wire.

Straight and gaunt
The poles stand;
They walk stiffly
Over a thousand leagues
Of rough land.

[31]

The Wrestler

The tired wind creeps down the canyon
At nightfall.
By day it turns and flings itself
Against the granite face of the mountains.

Foot-hills

New Mexico hills
Are spotted like lizards,
They sinuously glide and dissemble;
If you take a forked stick
You may catch one and hold it.

Waiting

More still than death
That waits a thousand years
In a new-ploughed field
Of up-turned bones;
So will I wait for you
A thousand years.

Afternoon

Earth tips to the west
And the hills lean backward—
Cedar-trees
Hugging the hillsides.

Smoke drifts in the valley—
The pinto sun
Nickers over the gate
Of the home corral.

Cactus

The cactus scrawls crude hieroglyphs against the
 sky;
It reaches with twisted, inquisitive fingers
To clutch the throat of something and question
 Why.

Stone-pine and Stream

The stone-pine with green branches
Stands on the brink of the canyon,
The wind whispers in the tree—
The wind lifts my hair.
Water runs with a pattern of braided and woven
 music
Through the stream in the canyon—
My body flows like water through the stream in the
 canyon.

Shadow

A deep blue shadow falls
On the face of the mountain—
What great bird's wing
Has dropped a feather?

Gold

Gold is under these hills;
And the wind piles sand
Through the cracks of deserted cabins.

Gold chinked over the counters,
Gold poured into the glasses,
Gold flickered and flamed
In the spendthrift gleam
Of a woman's hair . . .

Gold is under these hills,
Gold in the empty sunlight.

[33]

NIGHT

The night is dark, and the moon
Moves heavily, dragging a cross;
Penitent peaks drip, crowned with cactus;
The wind whips itself mournfully
Through the arroyos.

DESCANSO

Beside this wooden cross
By the cross of the desert cactus,
The coffin-bearers rested:
"Pray for the soul
Of Manuel Rodriguez,"
And remember
That death is the end of life.

PUEBLO

The pueblo rises under the sun-bronzed noon
As if hammered out of copper;
The sky's metallic blue
Rings in the silence.
Nothing moves but the shapes
That strain without changing.

DOUBLE

Who is this running with me
Whose shadow alone I see,
And at high noon hear only
The soft tread of his sandals?

FIESTA

The sun dances to the drums
With cottonwood boughs
On head and ankles.

The moon steps softly
In a turquoise tablita.

The stars run to pick up
The eagle feathers
Dropped by the dancers.

FROM THE STONE AGE

Long ago some one carved me in the semblance of
 a god.
I have forgot now what god I was meant to repre-
 sent.
I have no consciousness now but of stone, sunlight,
 and rain;
The sun baking my skin of stone, the wind lifting
 my hair:
The sun's light is hot upon me,
The moon's light is cool,
Casting a silver-laced pattern of light and dark
Over the planes of my body:
My thoughts now are the thoughts of a stone,
My substance now is the substance of life itself;
I have sunk deep into life as one sinks into sleep;
Life is above me, below me, around me,
Moving through my pores of stone—
It does not matter how small the space you pack
 life in,
That space is as big as the universe—
Space, volume, and the overtone of volume
Move through me like chords of music,
Like the taste of happiness in the throat,
Which you fear to lose, though it may choke you—
(In the cities this is not known,
For space there is emptiness,
And time a torment)
Since I became a stone
I have no need to remember anything—
Everything is remembered for me;
I live and I think and I dream as a stone,

In the warm sunlight, in the grey rain;
All my surfaces are touched to softness
By the light fingers of the wind, •
The slow dripping of rain:
My body retains only faintly the image
It was meant to represent,
I am more beautiful and less rigid,
I am a part of space,
Time has entered into me,
Life has passed through me—
What matter the name of the god I was meant to
 represent?

CANDLE-LIGHT AND SUN

CANDLE-LIGHT

It might have been me in the darkened room
With the shutters closed,
Lying straight and slim
In the shuttered dusk,
In the twilight dim:
Like a silken husk
When the corn is gone,
Life withdrawn;
I am living, and she is dead—
Or is it I who have died instead?

THE MASK

Death is a beautiful white mask,
That slips over the face, when the moment comes,
To hide the happiness of the soul.

RAIN-PRAYER

A broken ploughed field
In the driving rain,
Rain driven slant-wise
Over the plain.
I long for the rain,
The dull long rain,
For farmlands and ploughlands
And cornlands again.
O grey broken skies,
You were part of my pain!

FAME

Fame is an echo
Far off, remote—
But love is a sweetness
You taste in the throat,
Friendship a comfort
When twilight falls.
But fame is an echo
Through empty halls.

SUNLIGHT

The sunlight is enough,
And the earth sucking life from the sun.
Horses in a wide field are a part of it,
Dappled and white and brown;
Trees are another kind of life,
Linked to us but not understood.
(Whoever can understand a horse or a tree
Can understand a star or a planet:
But one may feel things without understanding,
Or one may understand them through feeling.)
The simple light of the sun is enough.
One will never remember
A greater thing when one dies
Than sunlight falling aslant long rows of corn,
Or rainy days heavy with grey sullen skies.
Not love, not the intense moment of passion,
Not birth, is as poignant
As the sudden flash that passes
Like light reflected in a mirror
From nature to us.

THE EAGLE'S SONG

The eagle sings to the sea-gull,
"My eyes are blind with pain,
Peering into the sun's face,
As yours in the tossing main;

Yours are the depths of the sea,
Mine the fathomless sky,
Between us the tides of men
Who blossom, and fall, and die."

The eagle sings to the sea-gull,
"The world will toss and strain
Till the mountains march to the sea,
And the sea climbs back again."

The eagle sings to the sea-gull,
"The mountains wait and sleep."
And the sea-gull sings to the eagle
The old sing-song of the deep.

ON THE ACEQUIA MADRE

Death has come to visit us today,
He is such a distinguished visitor
Everyone is overcome by his presence—
"Will you not sit down—take a chair?"

But Death stands in the doorway, waiting to depart;
He lingers like a breath in the curtains.
The whole neighborhood comes to do him honor,
Women in black shawls and men in black sombreros
Sitting motionless against white-washed walls;
And the old man with the grey stubby beard
To whom death came,
Is stunned into silence.
Death is such a distinguished visitor,
Making even old flesh important.

But who now, I wonder, will take the old horse to
 pasture?

PEDRO MONTOYA OF ARROYO HONDO

Pedro Montoya of Arroyo Hondo
Comes each day with his load of wood
Piled on two burros' backs, driving them down
Over the mesa to Santa Fe town.

He comes around by Arroyo Chamisa—
A small grey figure, as grey as his burros—
Down from the mountains, with cedar and pine
Girt about each of the burros with twine.

As patient as they are, he waits in the plaza
For someone who comes with an eye out for wood,
Then Pedro wakes up, like a bantam at dawn—
Si, Señor, si Señor—his wood is gone.

Pedro Montoya of Arroyo Hondo
Rides back on one burro and drives the other,
With a sack of blue corn-meal, tobacco and meat,
A bit to smoke and a bit to eat.

Pedro Montoya of Arroyo Hondo—
If I envied any, I'd envy him!
With a burro to ride and a burro to drive,
There is hardly a man so rich alive.

UNA ANCIANA MEXICANA

I've seen her pass with eyes upon the road—
An old bent woman in a bronze black shawl,
With skin as dried and wrinkled as a mummy's,
As brown as a cigar-box, and her voice
Like the low vibrant strings of a guitar.
And I have fancied from the girls about
What she was at their age, what they will be
When they are old as she. But now she sits
And smokes away each night till dawn comes round,
Thinking, beside the piñons' flame, of days
Long past and gone, when she was young—content
To be no longer young, her epic done:

> For a woman has work and much to do,
> And it's good at the last to know it's through,
> And still have time to sit alone,
> To have some time you can call your own.
> It's good at the last to know your mind
> And travel the paths that you traveled blind,
> To see each turn and even make
> Trips in the byways you did not take—
> But that, *por Dios*, is over and done,
> It's pleasanter now in the way we've come;
> It's good to smoke and none to say
> What's to be done on the coming day,
> No mouths to feed or coat to mend,
> And none to call till the last long end.
> Though one have sons and friends of one's own,
> It's better at last to live alone.
> For a man must think of food to buy,
> And a woman's thoughts may be wild and high;
> But when she is young she must curb her pride,
> And her heart is tamed for the child at her side.

But when she is old her thoughts may go
Wherever they will, and none to know.
And night is the time to think and dream,
And not to get up with the dawn's first gleam;
Night is the time to laugh or weep,
And when dawn comes it is time to sleep . . .

When it's all over and there's none to care,
I mean to be like her and take my share
Of comfort when the long day's done,
And smoke away the nights, and see the sun
Far off, a shrivelled orange in a sky gone black,
Through eyes that open inward and look back.

MADRE MARIA

From the Spanish

On the mountain Lucia
Was Madre Maria,
With book of gold.
Half was she reading,
Half praying and pleading
For sorrow foretold.

Came her son Jesus
To the mountain Lucia:
"What are you doing then,
Madre Maria?"

"Nor reading nor sleeping,
But dreaming a dream.
On Calvary's hill-top
Three crosses gleam,
Bare in the moonlight;
Your body on one
Nailed feet and hands,
O my dear little son!"

"Be it so, be it so,
O mi Madre Maria!"

Who says this prayer
Three times a day
Will find Heaven's doors
Opened alway,
And Hell's doors shut
Forever and aye.
Amen, Jesus!

CUNDIYO

As I came down from Cundiyo,
Upon the road to Chimayo
 I met three women walking;
Each held a sorrow to her breast,
And one of them a small cross pressed—
 Three black-shawled women walking.

"Now why is it that you must go
Up the long road to Cundiyo?"
 The old one did the talking:
"I go to bless a dying son."
"And I a sweetheart never won."
 Three women slowly walking.

The third one opened wide her shawl
And showed a new-born baby small
 That slept without a sorrow:
"And I, in haste that we be wed—
Too late, too late, if he be dead!
 The Padre comes tomorrow."

As I went up to Cundiyo,
In the grey dawn from Chimayo,
 I met three women walking;
And over paths of sand and rocks
Were men who carried a long box—
 Beside three women walking.

MANZANITA

From the Spanish

Little red apple upon the tree,
If you are not in love, fall in love with me! ...

From me this night you shall not go,
Not till the dawn, when the first cocks crow.

CHULA LA MAÑANA

From the Spanish

Pretty is the morning,
 Pretty is the day.
When the moon comes up
 It is light as day.

 Fortune's wheel keeps turning!

Yes, Fortune has its ups and downs,
 Fortune is a bubble.
It was all for a married woman
 I had my trouble.

 Fortune's wheel keeps turning!

It was eight o'clock at the bridge,
 And nine at Jesus Maria,
But before I could reach her door,
 I was caught by her fat old *tia!*

 Fortune's wheel keeps turning!

"CHRIST IS BORN IN BETHLEHEM"
A New Mexico Nursery Rhyme

Cristo nacio is what the rooster said,
And the hen said, *En Belen!*
The goats were so curious that they said
Vamos a ver—let us go see!
But the wise old sheep said,
No es menester!—there's no need of it!

> *Cristo nacio*
> *En Belen!*
> *Vamos a ver*—
> *No es menester!*

LA MUERTE DE LA VIEJA

There were four old women as old as she
Who knelt in the room where the sick one lay,
And the *resador* with his book of prayers
Who sat by her side all night to pray.

In the morning light her face was grey
As the ash that covered the embers still,
The black-shawled women had never stirred
And the old man's voice was hoarse and shrill.

The crucifix laid on her heaving breast
Moved with her harsh breath up and down,
And her mouth like a chicken's gaped for air
With a noise that the droning could not drown.

The sunlight poured through the open door
Where I stood and wondered how it could be
That the old, old woman with such great strength
Fought with the force we could not see.

As she had fought long years ago
Through child-bed pain, now her body thin
Strove to the last with the mid-wife Death,
Till silence ushered her new life in.

JUAN QUINTANA

The goat-herd follows his flock
Over the sandy plain,
And the goats nibble the rabbit-bush
Acrid with desert rain.

Old Juan Quintana's coat
Is a faded purple blue,
And his hat is a warm plum-brown,
And his trousers a tawny hue;

He is sunburnt like the hills,
And his eyes have a strange goat-look,
And when I came on him alone,
He suddenly quivered and shook.

Out in the hills all day,
The trees do funny things—
And a horse shaped like a man
Rose up from the ground on wings.

And a burro came and stood
With a cross, and preached to the flock,
While old Quintana sat
As cold as ice on a rock.

And sometimes the mountains move,
And the mesa turns about,
And Juan Quintana thinks he's lost,
Till a neighbor hears him shout.

And they say with a little laugh
That he isn't quite right, up here;
And they'll have to get a *muchacho*
To help with the flock next year.

PETROLINO'S COMPLAINT

The old ways have changed since you walked here,
 But worst of all is the way the people have
 become.
They have no hearts, and their minds are like putty,
 And if you ask for conversation, they might as
 well be dumb!

Though I am old, and my sight is not good,
 And I don't hear as well—*muy verdad*—as some,
With my stick I can walk faster than many,
 And my mind travels faster than a man's with
 no tongue!

The young have no thought for their elders,
 Their ranches are now no bigger than your thumb,
The young men work in the mines in Colora'o,
 Or they sit and warm their stomachs in the sun!

The girls spend their money on big hats and velvet,
 But when they would marry, they haven't the
 sum;
And the old songs and dances are forgotten,
 As the Saints will be forgotten—if they go on as
 they've begun!

I have gone looking through hillsides and canyons,
 Through all the *placitas* where we used to run;
But the old ways have changed since you walked
 here,
 And a goat is more sociable than a man that is
 dumb!

EL COYOTITO

From the Spanish

When I left Hermosillo
 My tears fell like rain,
But the little red flower
 Consoled my pain.

I am like the coyote
 That rolls them, and goes
Trotting off side-ways,
 And nobody knows.

The green pine has fallen,
 Where the doves used to pair;
Now the black one may find on returning
 Little tow-heads with sandy hair!

The adobe is gone
 Where my sword hung suspended;
Why worry—when everything's
 At the last ended?

The adobe is gone
 Where my mirror was bright,
And the small cedar tree
 Is the rabbit's tonight.

The cactus is bare
 Where the tunas were sweet;
No longer need you be jealous
 Of the women I meet.

Friends, if you see her
 In the hills up above,
Don't tell her that I am in prison—
 For she is my love.

[54]

NOTES

NOTES

PAGE 23. *Indian Songs:* Based on the literal translations made by Miss Frances Densmore. (Chippewa Music, Bulletins 45 and 53, Bureau of American Ethnology.)

Indian poetry, in its most characteristic form, is at the opposite pole from narrative or descriptive poetry, or even from the usual occidental lyric, which gives a double image, i. e., the original emotional stimulus *through* the thought or emotion aroused by it. Indian poetry is seldom self-conscious to this degree. It gives the naked image, or symbol, which is itself the emotional stimulus. The distinction is subtle, but one who would interpret or translate Indian verse must perceive it.

PAGE 27. *Corn-Grinding Song:* This song was given me by Canuto Suaza, a Tesuque Indian, who translated it for me from the Tewa, in both Spanish and English. My rendering is as direct as possible.

PAGE 29. *The Green Corn Dance:* The symbolism of Indian dances, carried out in every detail of costume, gesture, and song, takes such a hold upon the imagination that one becomes only half conscious of the dancers, lost in that archetypal world of which the dance furnishes a symbolic mirror.

PAGE 46. *Madre María:* From a Spanish version obtained by Miss Barbara Freire-Marreco from an Indian woman at the Santa Clara Pueblo. The Indians have preserved many of the traditional and popular Spanish New Mexico songs. This is an old song, probably brought to New Mexico by the early Franciscans, other versions of it having been found in South America. The final stanza is obviously a local addition.

PAGES 48, 50. *Manzanita* and the New Mexico Nursery rhyme *"Christ is Born in Bethlehem"* were given me by Mrs. N. Howard Thorp of Santa Fe.

PAGE 49. *Chula la Mañana* is a free translation of a popular New Mexico song. (The word *tía* means *aunt.*) There are many versions of this song in the southwest and in old Mexico.

PAGE 54. *El Coyotito* is from the Spanish version in *C*harles F. Lummis' *The Land of Poco Tiempo*. Mr. Lummis himself has made an excellent translation of the song, but has left out, perhaps judiciously, some of the tang. His translation, however, is fitted to the music accompanying the original song; while mine has created a new rhythm.